ROYAL
BALLET

DIARY 2021

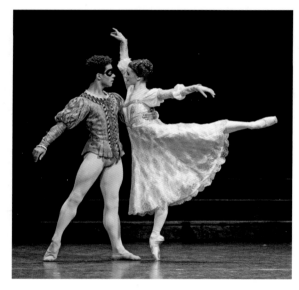

First published in 2020

20 22 24 23 21

1 3 5 7 9 10 8 6 4 2

Created and produced by
FLAME TREE PUBLISHING
6 Melbray Mews,
London SW6 3NS, UK
Tel: +44 (0) 20 7751 9650
Fax: +44 (0) 20 7751 9651
info@flametreepublishing.com
www.flametreepublishing.com

ISBN: 978-1-83964-101-5

Front cover: Marcelino Sambé as Romeo and Anna Rose O'Sullivan as Juliet in *Romeo and Juliet*
Choreography Kenneth MacMillan (1965)
© 2019 ROH. Photograph by Helen Maybanks

Back cover: Francesca Hayward in 'Ondine' in Margot Fonteyn: A Celebration
Choreography Frederick Ashton (1958)
© 2019 ROH. Photograph by Andrej Uspenski

A CIP record for this book is available from the British Library upon request.

Every attempt has been made to ensure the accuracy of the date information at the time of going
to press, and the publishers cannot accept responsibility for any errors. Some public holidays are subject
to change by Royal or State proclamation. At the time of publication, accurate information was unavailable
for all religious celebrations in 2021. All Jewish and Islamic holidays begin at sunset on the previous
day and end at sunset on the date shown. Moon phases are based on GMT.

Every effort has been made to contact all copyright holders. The publishers
would be pleased to hear if any oversights or omissions have occurred.

Created and Published in UK. Printed in China.

● New Moon

◐ First Quarter

○ Full Moon

◑ Last Quarter

FSC
www.fsc.org

MIX
Paper from
responsible sources
FSC® C005748

2020

JANUARY
M	T	W	T	F	S	S
		1	2	3	4	5
6	7	8	9	10	11	12
13	14	15	16	17	18	19
20	21	22	23	24	25	26
27	28	29	30	31		

FEBRUARY
M	T	W	T	F	S	S
					1	2
3	4	5	6	7	8	9
10	11	12	13	14	15	16
17	18	19	20	21	22	23
24	25	26	27	28	29	

MARCH
M	T	W	T	F	S	S
						1
2	3	4	5	6	7	8
9	10	11	12	13	14	15
16	17	18	19	20	21	22
23	24	25	26	27	28	29
30	31					

APRIL
M	T	W	T	F	S	S
		1	2	3	4	5
6	7	8	9	10	11	12
13	14	15	16	17	18	19
20	21	22	23	24	25	26
27	28	29	30			

MAY
M	T	W	T	F	S	S
				1	2	3
4	5	6	7	8	9	10
11	12	13	14	15	16	17
18	19	20	21	22	23	24
25	26	27	28	29	30	31

JUNE
M	T	W	T	F	S	S
1	2	3	4	5	6	7
8	9	10	11	12	13	14
15	16	17	18	19	20	21
22	23	24	25	26	27	28
29	30					

JULY
M	T	W	T	F	S	S
		1	2	3	4	5
6	7	8	9	10	11	12
13	14	15	16	17	18	19
20	21	22	23	24	25	26
27	28	29	30	31		

AUGUST
M	T	W	T	F	S	S
					1	2
3	4	5	6	7	8	9
10	11	12	13	14	15	16
17	18	19	20	21	22	23
24	25	26	27	28	29	30
31						

SEPTEMBER
M	T	W	T	F	S	S
	1	2	3	4	5	6
7	8	9	10	11	12	13
14	15	16	17	18	19	20
21	22	23	24	25	26	27
28	29	30				

OCTOBER
M	T	W	T	F	S	S
			1	2	3	4
5	6	7	8	9	10	11
12	13	14	15	16	17	18
19	20	21	22	23	24	25
26	27	28	29	30	31	

NOVEMBER
M	T	W	T	F	S	S
						1
2	3	4	5	6	7	8
9	10	11	12	13	14	15
16	17	18	19	20	21	22
23	24	25	26	27	28	29
30						

DECEMBER
M	T	W	T	F	S	S
	1	2	3	4	5	6
7	8	9	10	11	12	13
14	15	16	17	18	19	20
21	22	23	24	25	26	27
28	29	30	31			

2021

JANUARY
M	T	W	T	F	S	S
				1	2	3
4	5	6	7	8	9	10
11	12	13	14	15	16	17
18	19	20	21	22	23	24
25	26	27	28	29	30	31

FEBRUARY
M	T	W	T	F	S	S
1	2	3	4	5	6	7
8	9	10	11	12	13	14
15	16	17	18	19	20	21
22	23	24	25	26	27	28

MARCH
M	T	W	T	F	S	S
1	2	3	4	5	6	7
8	9	10	11	12	13	14
15	16	17	18	19	20	21
22	23	24	25	26	27	28
29	30	31				

APRIL
M	T	W	T	F	S	S
			1	2	3	4
5	6	7	8	9	10	11
12	13	14	15	16	17	18
19	20	21	22	23	24	25
26	27	28	29	30		

MAY
M	T	W	T	F	S	S
					1	2
3	4	5	6	7	8	9
10	11	12	13	14	15	16
17	18	19	20	21	22	23
24	25	26	27	28	29	30
31						

JUNE
M	T	W	T	F	S	S
	1	2	3	4	5	6
7	8	9	10	11	12	13
14	15	16	17	18	19	20
21	22	23	24	25	26	27
28	29	30				

JULY
M	T	W	T	F	S	S
			1	2	3	4
5	6	7	8	9	10	11
12	13	14	15	16	17	18
19	20	21	22	23	24	25
26	27	28	29	30	31	

AUGUST
M	T	W	T	F	S	S
						1
2	3	4	5	6	7	8
9	10	11	12	13	14	15
16	17	18	19	20	21	22
23	24	25	26	27	28	29
30	31					

SEPTEMBER
M	T	W	T	F	S	S
		1	2	3	4	5
6	7	8	9	10	11	12
13	14	15	16	17	18	19
20	21	22	23	24	25	26
27	28	29	30			

OCTOBER
M	T	W	T	F	S	S
				1	2	3
4	5	6	7	8	9	10
11	12	13	14	15	16	17
18	19	20	21	22	23	24
25	26	27	28	29	30	31

NOVEMBER
M	T	W	T	F	S	S
1	2	3	4	5	6	7
8	9	10	11	12	13	14
15	16	17	18	19	20	21
22	23	24	25	26	27	28
29	30					

DECEMBER
M	T	W	T	F	S	S
		1	2	3	4	5
6	7	8	9	10	11	12
13	14	15	16	17	18	19
20	21	22	23	24	25	26
27	28	29	30	31		

2022

JANUARY
M	T	W	T	F	S	S
					1	2
3	4	5	6	7	8	9
10	11	12	13	14	15	16
17	18	19	20	21	22	23
24	25	26	27	28	29	30
31						

FEBRUARY
M	T	W	T	F	S	S
	1	2	3	4	5	6
7	8	9	10	11	12	13
14	15	16	17	18	19	20
21	22	23	24	25	26	27
28						

MARCH
M	T	W	T	F	S	S
	1	2	3	4	5	6
7	8	9	10	11	12	13
14	15	16	17	18	19	20
21	22	23	24	25	26	27
28	29	30	31			

APRIL
M	T	W	T	F	S	S
				1	2	3
4	5	6	7	8	9	10
11	12	13	14	15	16	17
18	19	20	21	22	23	24
25	26	27	28	29	30	

MAY
M	T	W	T	F	S	S
						1
2	3	4	5	6	7	8
9	10	11	12	13	14	15
16	17	18	19	20	21	22
23	24	25	26	27	28	29
30	31					

JUNE
M	T	W	T	F	S	S
		1	2	3	4	5
6	7	8	9	10	11	12
13	14	15	16	17	18	19
20	21	22	23	24	25	26
27	28	29	30			

JULY
M	T	W	T	F	S	S
				1	2	3
4	5	6	7	8	9	10
11	12	13	14	15	16	17
18	19	20	21	22	23	24
25	26	27	28	29	30	31

AUGUST
M	T	W	T	F	S	S
1	2	3	4	5	6	7
8	9	10	11	12	13	14
15	16	17	18	19	20	21
22	23	24	25	26	27	28
29	30	31				

SEPTEMBER
M	T	W	T	F	S	S
			1	2	3	4
5	6	7	8	9	10	11
12	13	14	15	16	17	18
19	20	21	22	23	24	25
26	27	28	29	30		

OCTOBER
M	T	W	T	F	S	S
					1	2
3	4	5	6	7	8	9
10	11	12	13	14	15	16
17	18	19	20	21	22	23
24	25	26	27	28	29	30
31						

NOVEMBER
M	T	W	T	F	S	S
	1	2	3	4	5	6
7	8	9	10	11	12	13
14	15	16	17	18	19	20
21	22	23	24	25	26	27
28	29	30				

DECEMBER
M	T	W	T	F	S	S
			1	2	3	4
5	6	7	8	9	10	11
12	13	14	15	16	17	18
19	20	21	22	23	24	25
26	27	28	29	30	31	

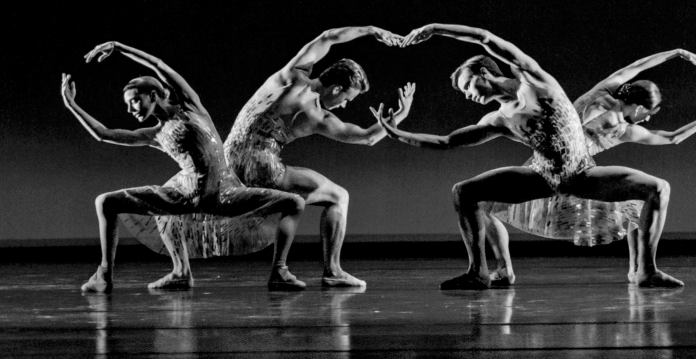

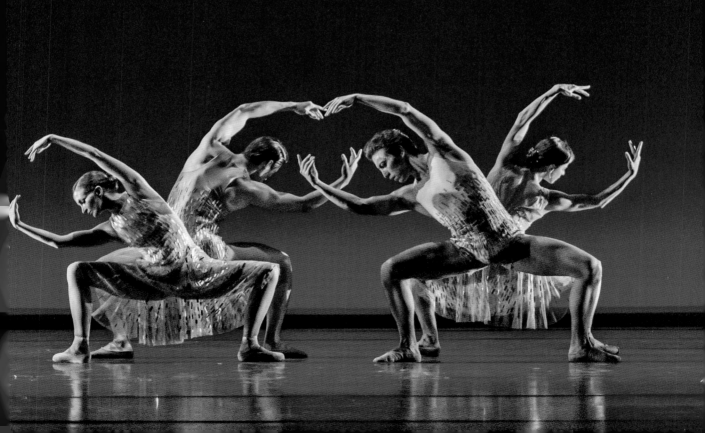

Personal Information

Name

Address

Telephone

Mobile

Fax

Email

Bank Telephone

Credit Card Telephone

National Insurance No.

Passport No.

Driving Licence No.

AA or RAC Membership No.

In Case of Emergency

Contact

Telephone

Doctor

Known Allergies

Notes

December 2020/January

28 Monday

29 Tuesday

30 Wednesday ○

31 Thursday

New Year's Eve

1 Friday

New Year's Day

2 Saturday

Public Holiday (Scot, NZ)

3 Sunday

January

4 Monday

Public Holiday (Scot, NZ) (observed)

5 Tuesday

◑ 6 Wednesday

Epiphany
Three Kings' Day

7 Thursday

8 Friday

9 Saturday

10 Sunday

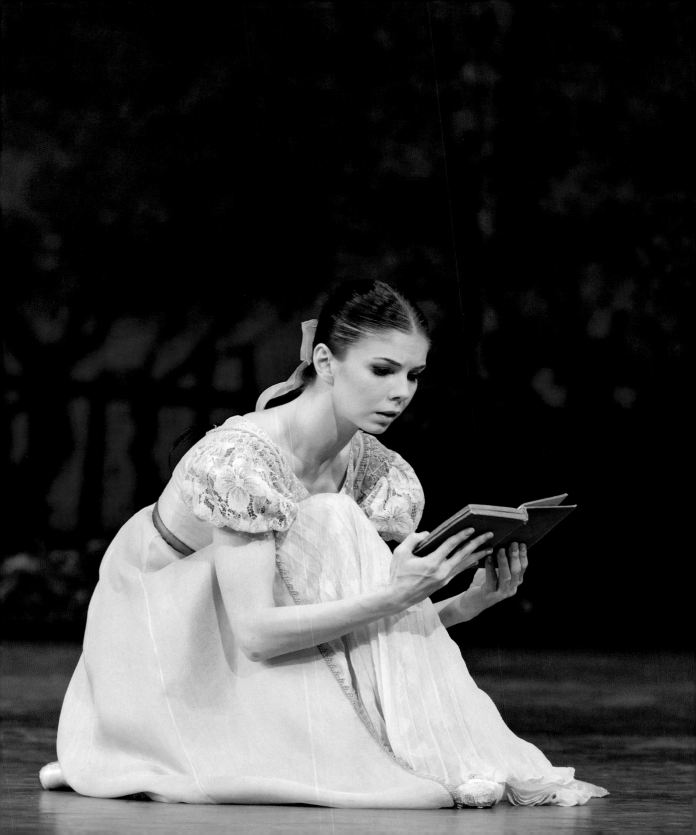

January

11 Monday

Coming of Age Day (Japan)

12 Tuesday

● 13 Wednesday

14 Thursday

Makar Sankranti

15 Friday

16 Saturday

17 Sunday

Natalia Osipova as Tatiana in *Onegin*
Choreography John Cranko (1965)
© 2015 ROH. Photograph by Tristram Kenton

January

18 Monday

Martin Luther King Jr Day (USA)

19 Tuesday

Birthday of Guru Gobind Singh

20 Wednesday

◑

21 Thursday

22 Friday

23 Saturday

24 Sunday

**Yasmine Naghdi as Princess Aurora and Matthew Ball
as Prince Florimund in *The Sleeping Beauty***
Choreography Marius Petipa (1890),
Production Monica Mason and Christopher Newton (2006)
© 2017 ROH. Photograph by Bill Cooper

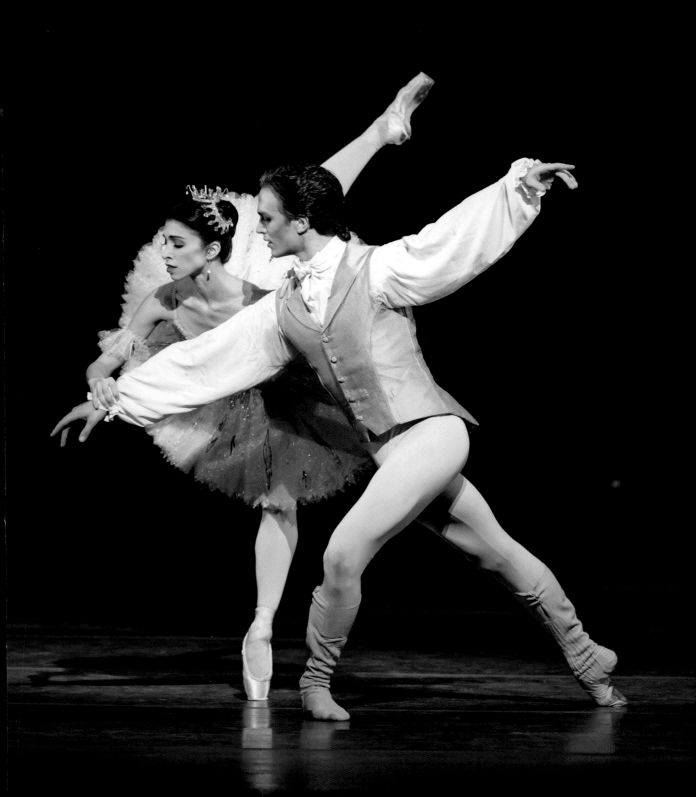

January

25 Monday

Burns Night (Scot)

26 Tuesday

Australia Day

27 Wednesday

28 Thursday ○

29 Friday

30 Saturday

31 Sunday

February

1 Monday

2 Tuesday

Groundhog Day (USA, Canada)

3 Wednesday

4 Thursday

5 Friday

6 Saturday

Waitangi Day (NZ)

7 Sunday

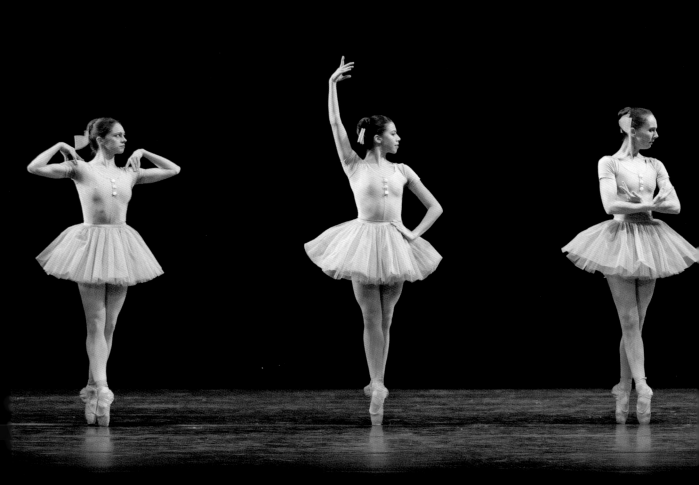

Artists of The Royal Ballet in *The Concert*
Choreography Jerome Robbins (1956)
© 2018 ROH. Photograph by Alice Pennefather

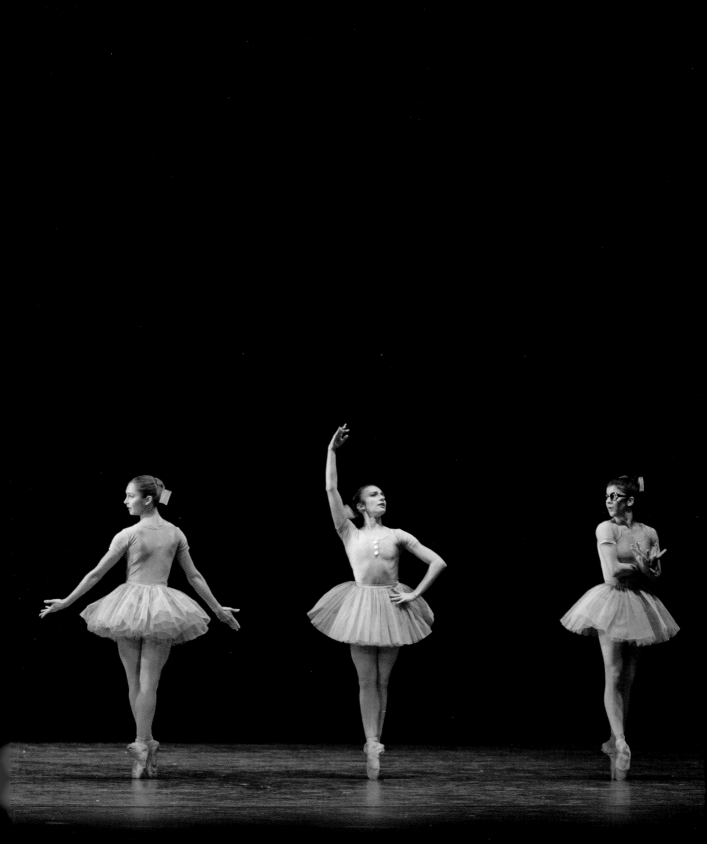

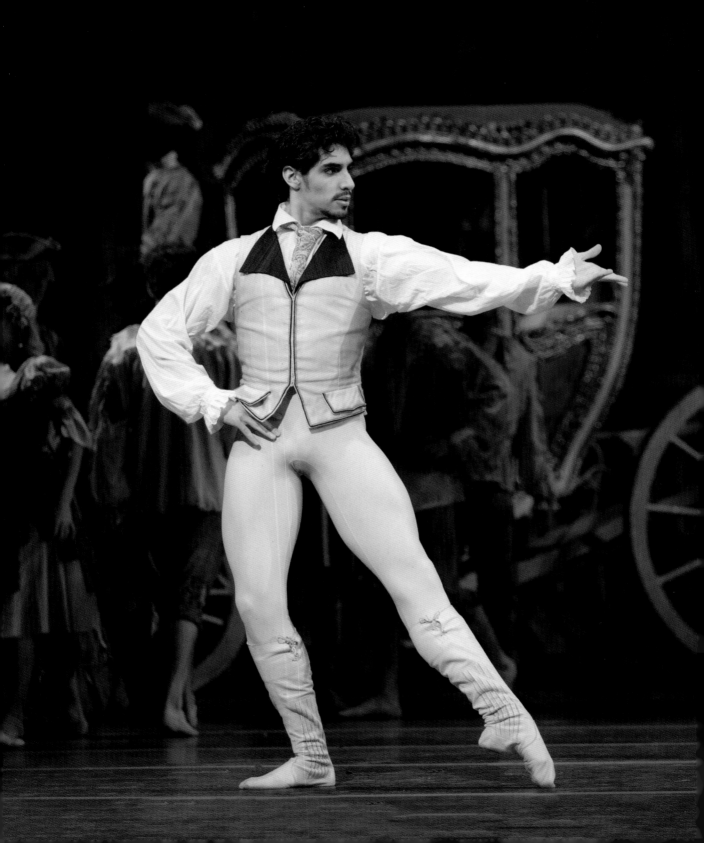

February

8 Monday

Waitangi Day (NZ) (observed)

9 Tuesday

10 Wednesday

● 11 Thursday

National Foundation Day (Japan)

12 Friday

Chinese New Year
Year of the Ox

13 Saturday

14 Sunday

St Valentine's Day

Cesar Corrales as Lescaut in *Manon*
Choreography Kenneth MacMillan (1974)
© 2019 ROH. Photograph by Alice Pennefather

February

WEEK 7

15 Monday

President's Day (USA)

16 Tuesday

Shrove Tuesday
Pancake Day
Vasant Panchami

17 Wednesday

Ash Wednesday

18 Thursday

19 Friday

◐

20 Saturday

21 Sunday

First Sunday of Lent

Melissa Hamilton as Princess Florine in *The Sleeping Beauty*
Choreography Marius Petipa (1890),
Production Monica Mason and Christopher Newton (2006)
© 2019 ROH. Photograph by Helen Maybanks

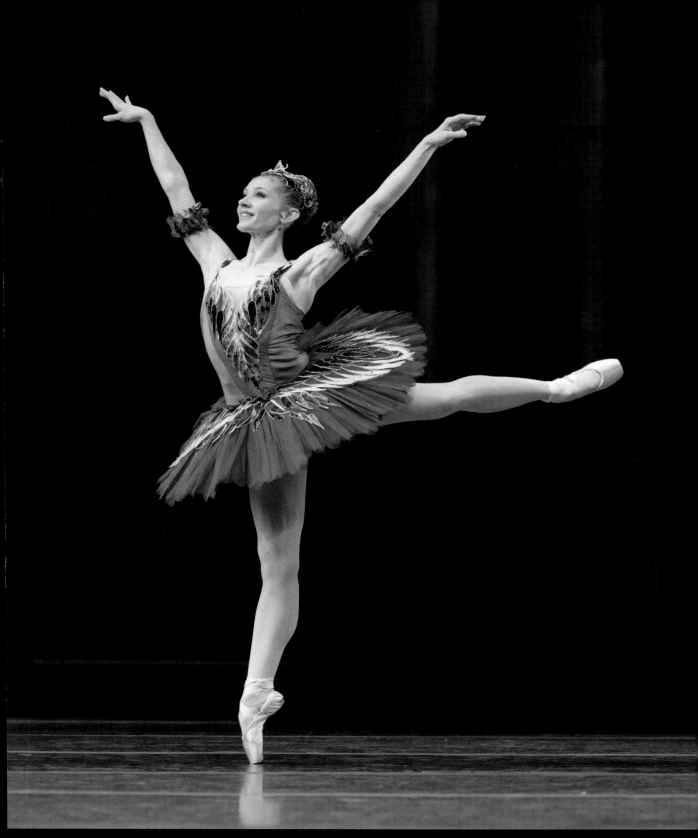

February

22 Monday

23 Tuesday

The Emperor's Birthday (Japan)

24 Wednesday

25 Thursday

26 Friday

Purim

27 Saturday

○

28 Sunday

March

1 Monday

St David's Day (Wales)

2 Tuesday

3 Wednesday

4 Thursday

5 Friday

◑ 6 Saturday

7 Sunday

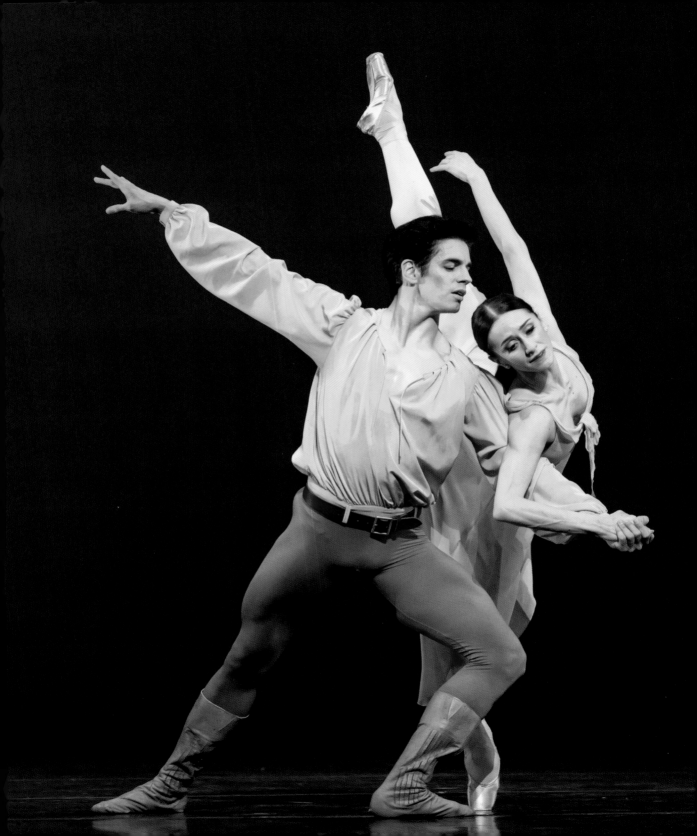

March

8 Monday

Commonwealth Day
International Women's Day

9 Tuesday

10 Wednesday

11 Thursday

Maha Shivaratri

12 Friday

● 13 Saturday

14 Sunday

Mother's Day (UK, Éire)

Federico Bonelli and Marianela Nuñez in *Dances at a Gathering*
Choreography Jerome Robbins (1969)
© 2020 ROH. Photograph by Bill Cooper

March

15 Monday

16 Tuesday

17 Wednesday

St Patrick's Day (Éire, N. Ireland)

18 Thursday

19 Friday

20 Saturday

Spring Equinox

21 Sunday

Human Rights Day (SA)

Marcelino Sambé as Basilio in *Don Quixote*
Choreography Carlos Acosta (2013)
after Marius Petipa
© 2019 ROH. Photograph by Andrej Uspenski

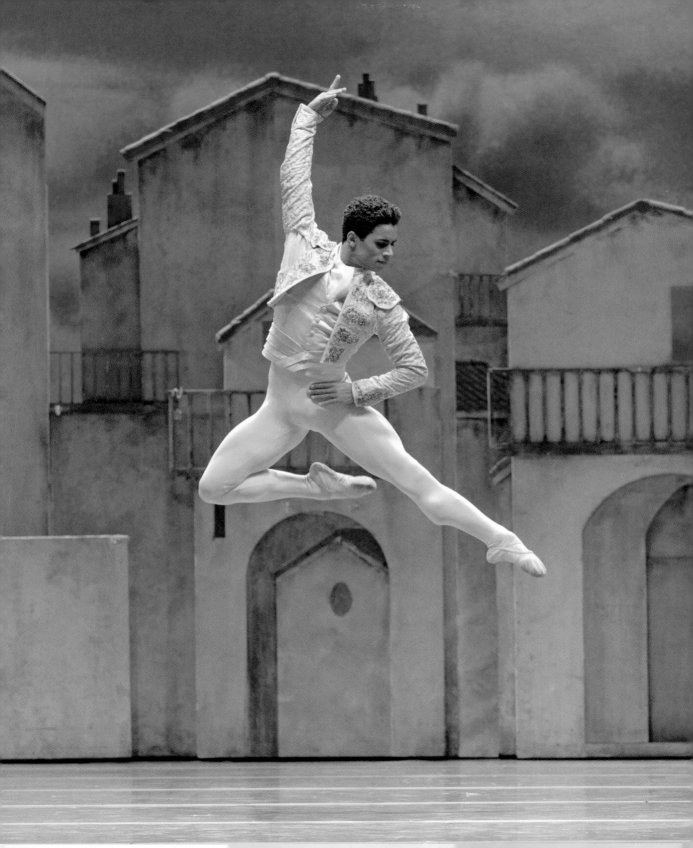

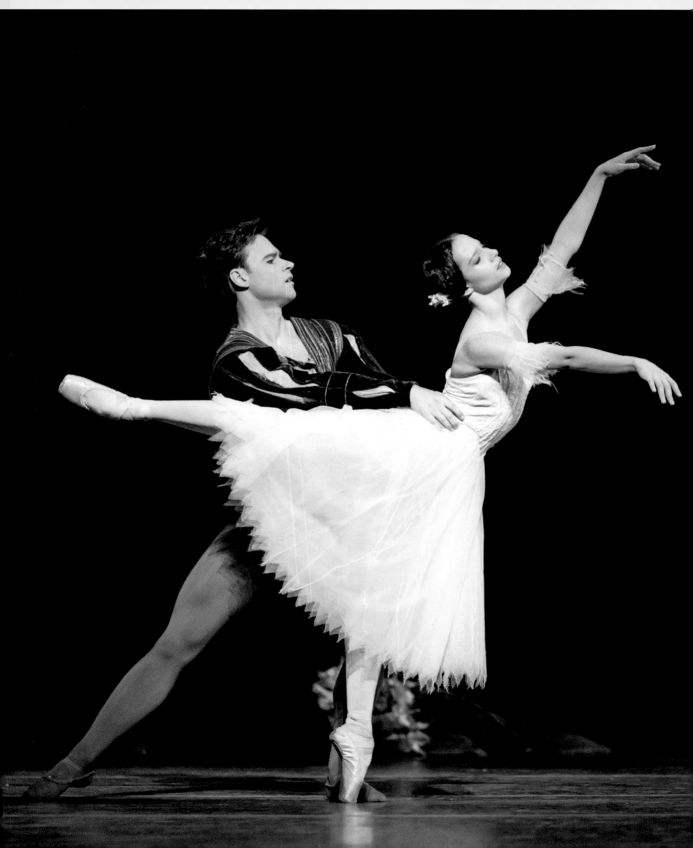

April

5 Monday

Easter Monday
Family Day (SA)

6 Tuesday

7 Wednesday

8 Thursday

9 Friday

10 Saturday

11 Sunday

Alexander Campbell as Albrecht and Francesca Hayward as Giselle in *Giselle*
Choreography Marius Petipa after Jean Coralli and Jules Perrot (1884),
Production Peter Wright (1985)
© 2018 ROH. Photograph by Helen Maybanks

April

WEEK 15

12 Monday ●

13 Tuesday

<div align="right">

Ramadan begins
Ramayana Week begins
Hindi New Year

</div>

14 Wednesday

<div align="right">

Vaisakhi

</div>

15 Thursday

16 Friday

17 Saturday

18 Sunday

<div align="right">

Benjamin Ella in *Something Borrowed* (New Work New Music)
Choreography Calvin Richardson (2019)
© 2019 ROH. Photograph by Alice Pennefather

</div>

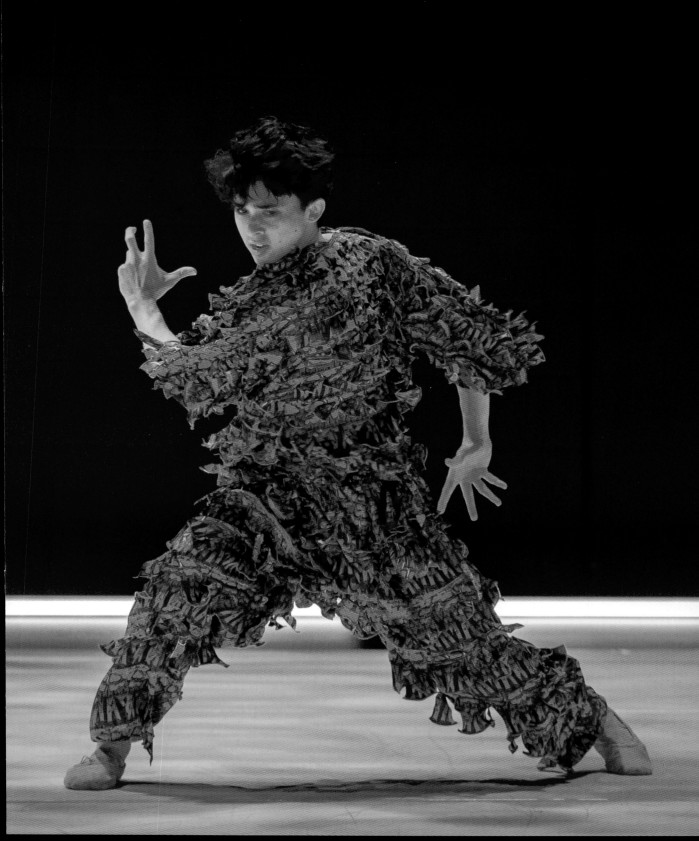

April

19 Monday

20 Tuesday ◑

21 Wednesday

Ramanavami

22 Thursday

23 Friday

St George's Day (England)

24 Saturday

25 Sunday

Anzac Day (AU, NZ)

April/May

26 Monday

Anzac Day (AU, NZ) (observed)

○ 27 Tuesday

Hanuman Jayanti
Freedom Day (SA)

28 Wednesday

29 Thursday

Shōwa Day (Japan)

30 Friday

1 Saturday

Workers' Day (SA)

2 Sunday

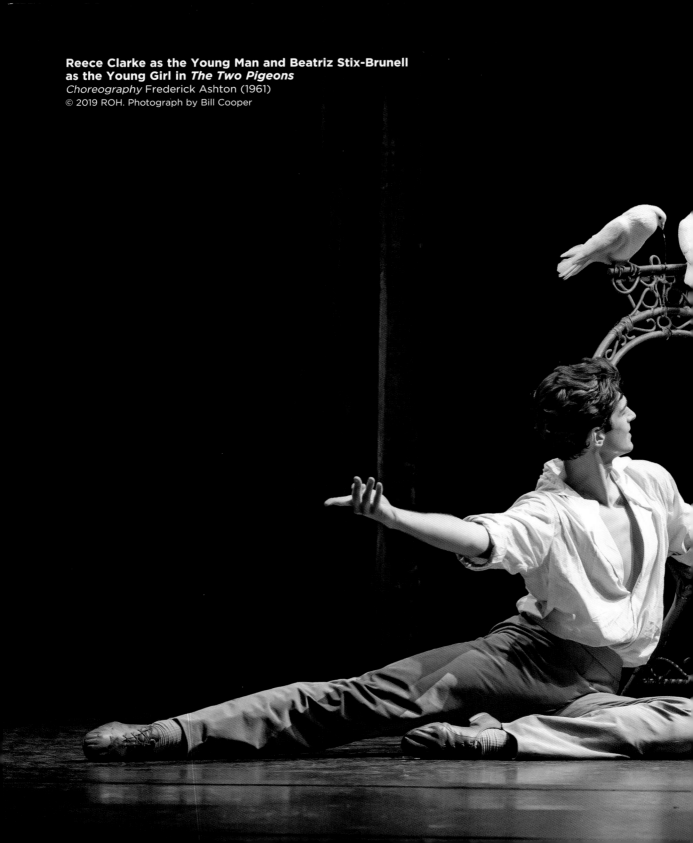

Reece Clarke as the Young Man and Beatriz Stix-Brunell as the Young Girl in *The Two Pigeons*
Choreography Frederick Ashton (1961)
© 2019 ROH. Photograph by Bill Cooper

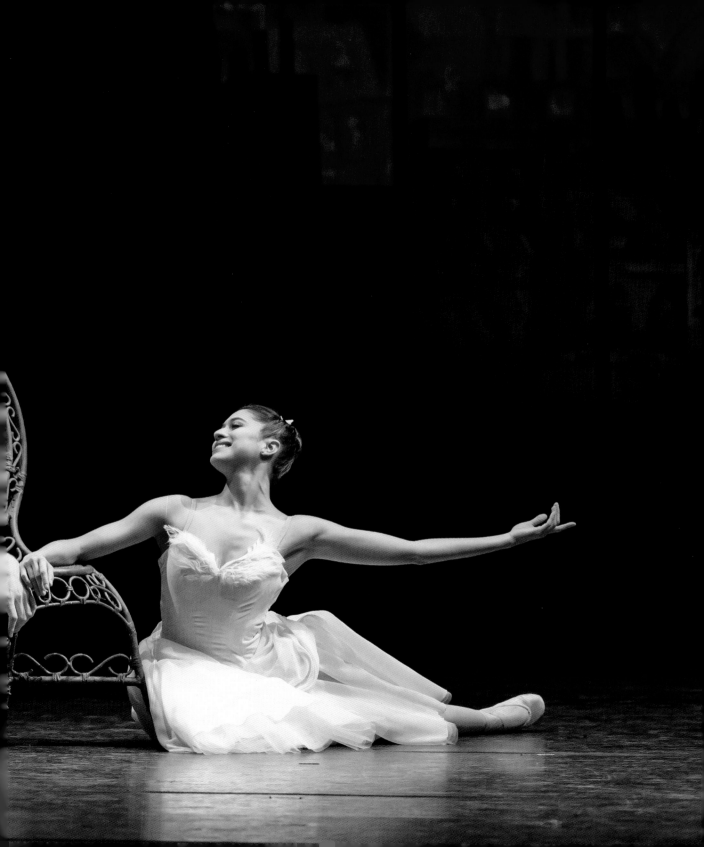

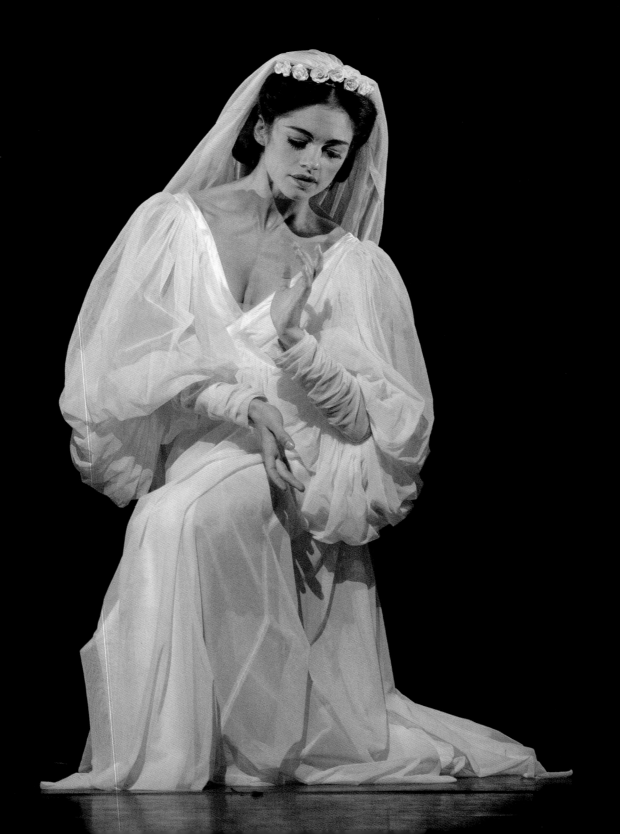

May

3 Monday

May Bank Holiday (UK, Éire)
Constitution Memorial Day (Japan)

4 Tuesday

Greenery Day (Japan)

5 Wednesday

Children's Day (Japan)

6 Thursday

7 Friday

8 Saturday

9 Sunday

Mother's Day (USA, Canada, AU, NZ, SA, Japan)

**Romany Pajdak in 'The Wise Virgins' in
Margot Fonteyn: A Celebration**
Choreography Frederick Ashton (1940)
© 2019 ROH. Photograph by Andrej Uspenski

May

10 Monday

11 Tuesday ⬤

12 Wednesday

Ramadan ends

13 Thursday

Eid al-Fitr
Ascension Day

14 Friday

15 Saturday

16 Sunday

**Yasmine Naghdi and Vadim Muntagirov in
'Le Corsaire' in Margot Fonteyn: A Celebration**
Choreography Marius Petipa (1899)
© 2019 ROH. Photograph by Andrej Uspenski

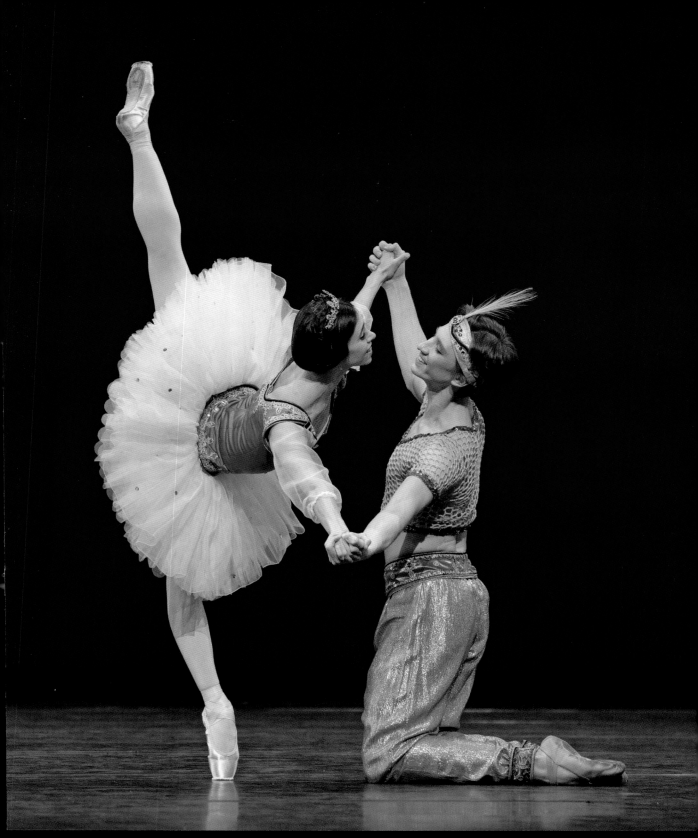

May

17 Monday

Shavuot begins

18 Tuesday

Shavuot ends

19 Wednesday

20 Thursday

21 Friday

22 Saturday

23 Sunday

Whit Sunday (Pentecost)

May

24 Monday

25 Tuesday

○ 26 Wednesday

27 Thursday

28 Friday

29 Saturday

30 Sunday

Trinity Sunday

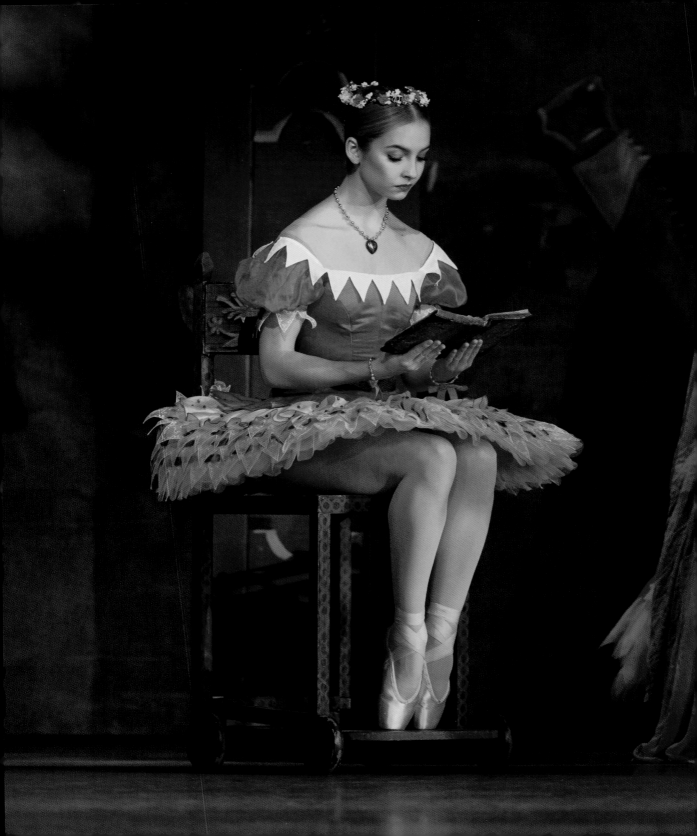

May/June

31 Monday

Spring Bank Holiday (UK)
Memorial Day (USA)

1 Tuesday

◑ 2 Wednesday

Coronation Day

3 Thursday

Corpus Christi

4 Friday

5 Saturday

6 Sunday

Ashley Dean as Coppélia in *Coppélia*
Choreography Marius Petipa (1933), *Additional Choreography* Enrico Cecchetti,
Lev Ivanov and Nicholas Grigorievich Sergeyev, *Production* Ninette de Valois (1954)
© 2019 ROH. Photograph by Bill Cooper

June

7 Monday

June Bank Holiday (Éire)

8 Tuesday

9 Wednesday

10 Thursday ●

11 Friday

12 Saturday

The Queen's Official Birthday (UK)

13 Sunday

Alexander Campbell as Basilio and Mayara Magri as Kitri in *Don Quixote*
Choreography Carlos Acosta (2013) after Marius Petipa
© 2019 ROH. Photograph by Andrej Uspenski

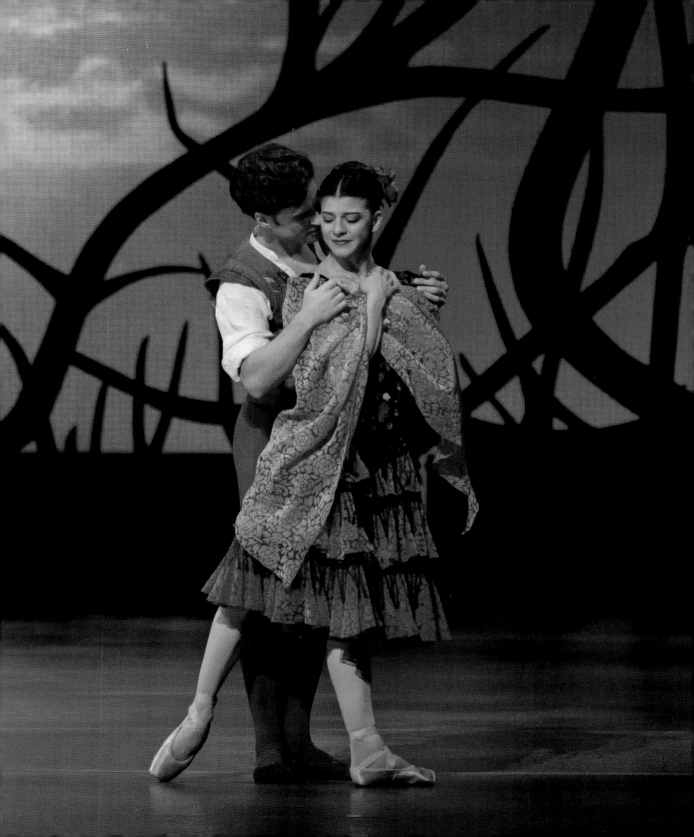

June

14 Monday

Dragon Boat Festival

15 Tuesday

16 Wednesday

Youth Day (SA)
Martyrdom of Guru Arjan Dev

17 Thursday

18 Friday ◑

19 Saturday

20 Sunday

Father's Day (UK, Éire, USA, Canada, SA, Japan)

June

21 Monday

Summer Solstice

22 Tuesday

Windrush Day (UK)

23 Wednesday

○ 24 Thursday

25 Friday

26 Saturday

27 Sunday

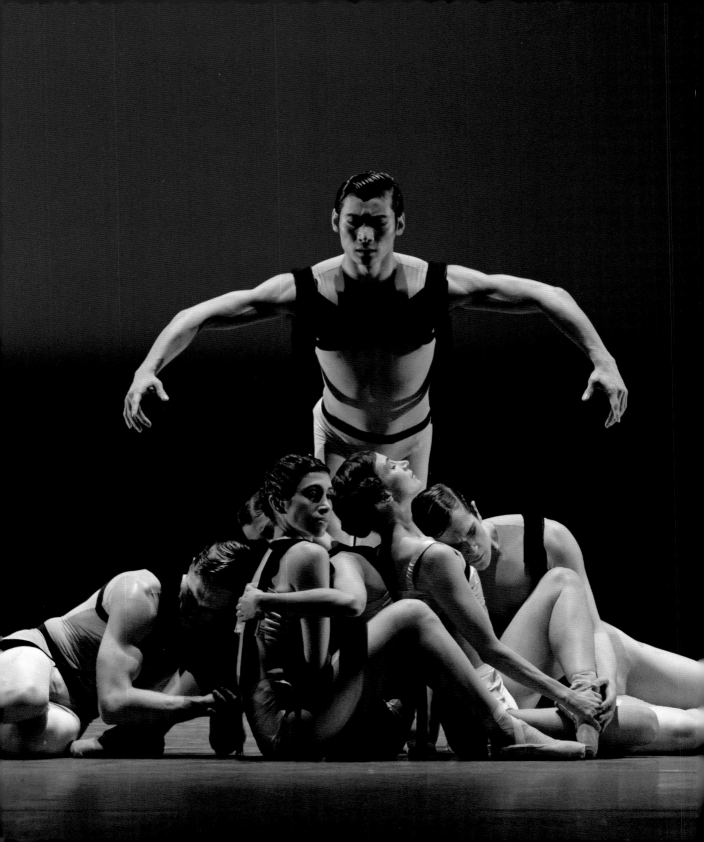

June/July

28 Monday

29 Tuesday

30 Wednesday

◐ 1 Thursday

Canada Day

2 Friday

3 Saturday

4 Sunday

Independence Day (USA)

Artists of The Royal Ballet in *Corybantic Games*
Choreography Christopher Wheeldon (2018)
© 2018 ROH. Photograph by Andrej Uspenski

July

5 Monday

6 Tuesday

7 Wednesday

8 Thursday

9 Friday

10 Saturday ●

11 Sunday

Itziar Mendizabal as The Firebird in *The Firebird*
Choreography Mikhail Fokine (1910)
© 2019 ROH. Photograph by Tristram Kenton

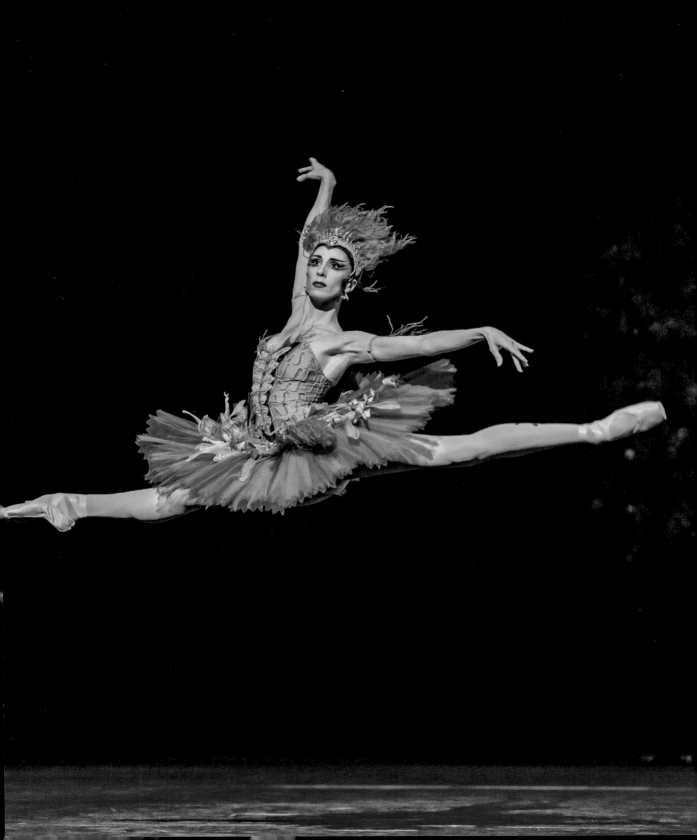

July

12 Monday

Battle of the Boyne (N. Ireland)

13 Tuesday

14 Wednesday

15 Thursday

16 Friday

17 Saturday ◐

18 Sunday

Tish'a B'Av

July

19 Monday

Marine Day (Japan)

20 Tuesday

Eid al-Adha

21 Wednesday

22 Thursday

23 Friday

○ 24 Saturday

25 Sunday

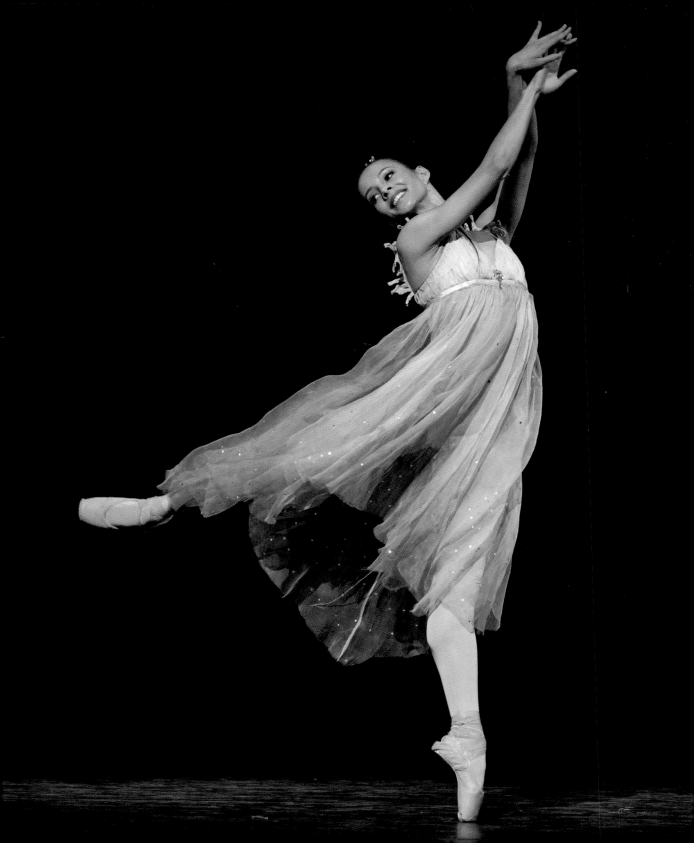

July/August

26 Monday

27 Tuesday

28 Wednesday

29 Thursday

30 Friday

31 Saturday

1 Sunday

Francesca Hayward in 'Ondine' in Margot Fonteyn: A Celebration
Choreography Frederick Ashton (1958)
© 2019 ROH. Photograph by Andrej Uspenski

August

2 Monday

Summer Bank Holiday (Scot)

August Bank Holiday (Éire)

3 Tuesday

4 Wednesday

5 Thursday

6 Friday

7 Saturday

8 Sunday ●

Sarah Lamb as Odette in *Swan Lake*
Choreography Marius Petipa and Lev Ivanov,
Additional Choreography Liam Scarlett and Frederick Ashton,
Production Liam Scarlett (2018)
© 2018 ROH. Photograph by Bill Cooper

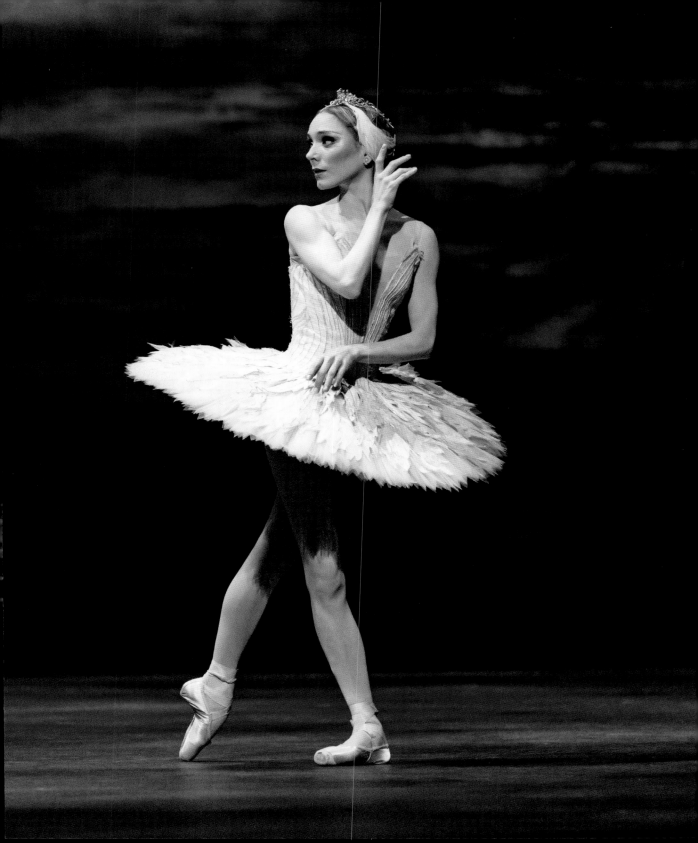

August

9 Monday

National Women's Day (SA)
Islamic New Year
Muḥarram

10 Tuesday

11 Wednesday

Mountain Day (Japan)

12 Thursday

13 Friday

14 Saturday

15 Sunday

August

16 Monday

17 Tuesday

18 Wednesday

19 Thursday

20 Friday

21 Saturday

○ 22 Sunday

Raksha Bandhan

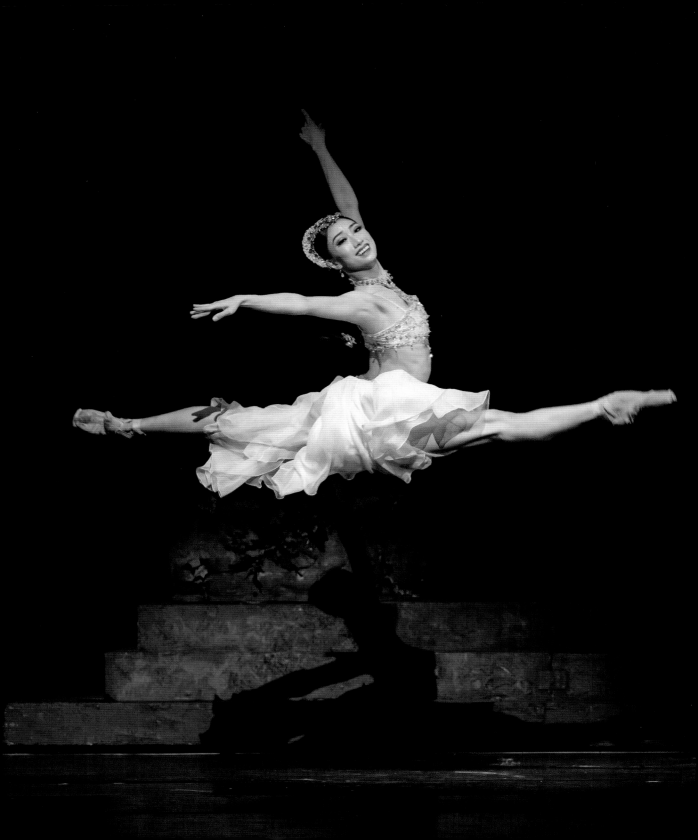

August

23 Monday

24 Tuesday

25 Wednesday

26 Thursday

27 Friday

28 Saturday

29 Sunday

Akane Takada as Nikiya in *La Bayadère*
Choreography Natalia Makarova (1980)
after Marius Petipa
© 2018 ROH. Photograph by Bill Cooper

August/September

30 Monday ◐

Summer Bank Holiday (UK except Scot)
Krishna Janmashthami

31 Tuesday

1 Wednesday

2 Thursday

3 Friday

4 Saturday

5 Sunday

Father's Day (AU, NZ)

Lauren Cuthbertson as Natalia Petrovna and Vadim Muntagirov as Beliaev in *A Month in the Country*
Choreography Frederick Ashton (1976)
© 2019 ROH. Photograph by Tristram Kenton

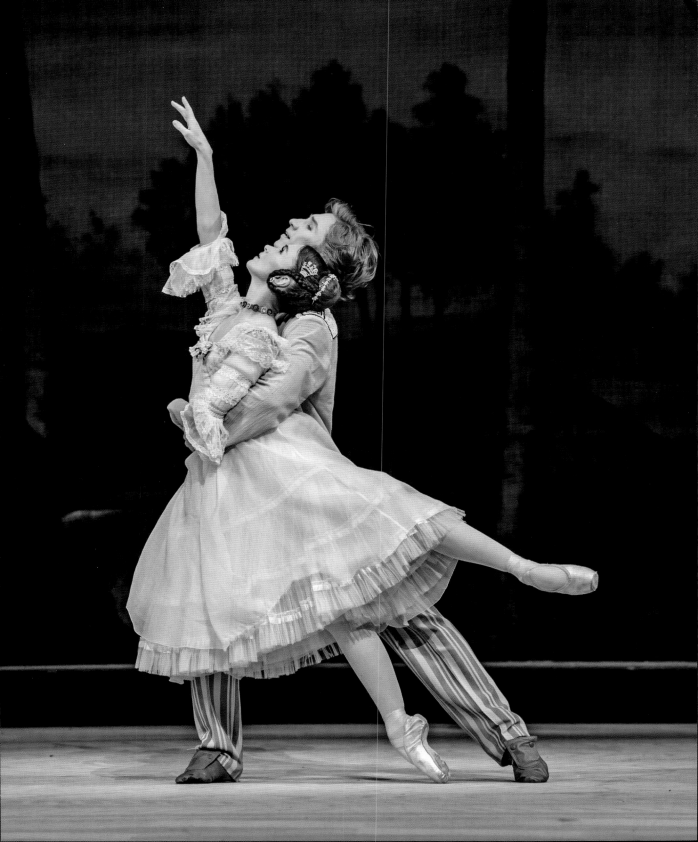

September

6 Monday

Labour Day (Canada, USA)

7 Tuesday

●

Jewish New Year (Rosh Hashanah) begins

8 Wednesday

Jewish New Year (Rosh Hashanah) ends

9 Thursday

10 Friday

Ganesh Chaturthi

11 Saturday

12 Sunday

Grandparents Day (USA, Canada)

September

◐ 13 Monday

14 Tuesday

15 Wednesday

16 Thursday

Day of Atonement (Yom Kippur)

17 Friday

18 Saturday

19 Sunday

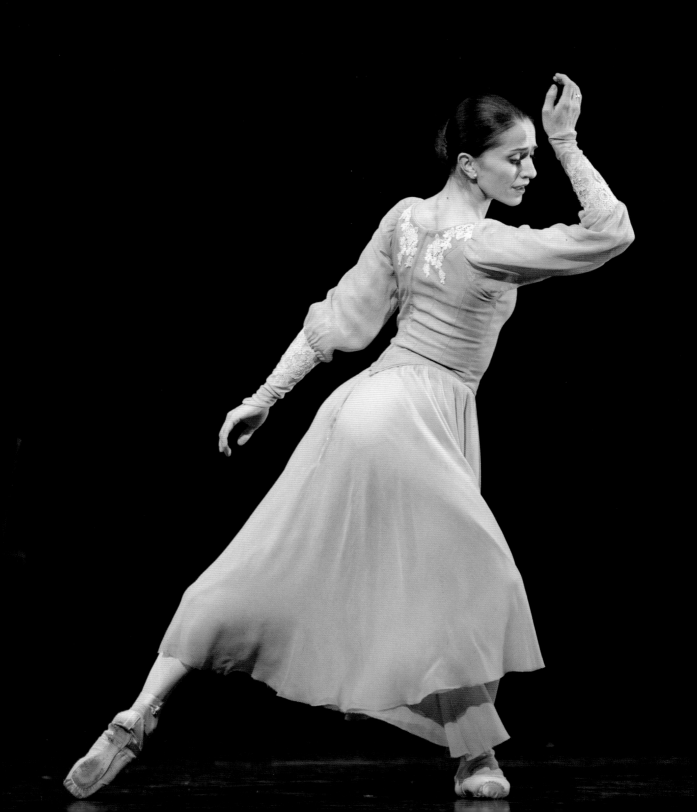

WEEK 38

September

○ 20 Monday

Respect for the Aged Day (Japan)

 21 Tuesday

International Day of Peace
First Day of Sukkot (Feast of Tabernacles)
Pitr-paksha begins

 22 Wednesday

Autumn Equinox

 23 Thursday

 24 Friday

Heritage Day (SA)

 25 Saturday

 26 Sunday

Marianela Nuñez as Masha in _Winter Dreams_
Choreography Kenneth MacMillan (1991)
© 2018 ROH. Photograph by Alice Pennefather

September/October

27 Monday

28 Tuesday

Shemini Atzeret

29 Wednesday

Simchat Torah

30 Thursday

1 Friday

2 Saturday

3 Sunday

Joseph Sissens in *Obsidian Tear*
Choreography Wayne McGregor (2016)
© 2018 ROH. Photograph by Tristram Kenton

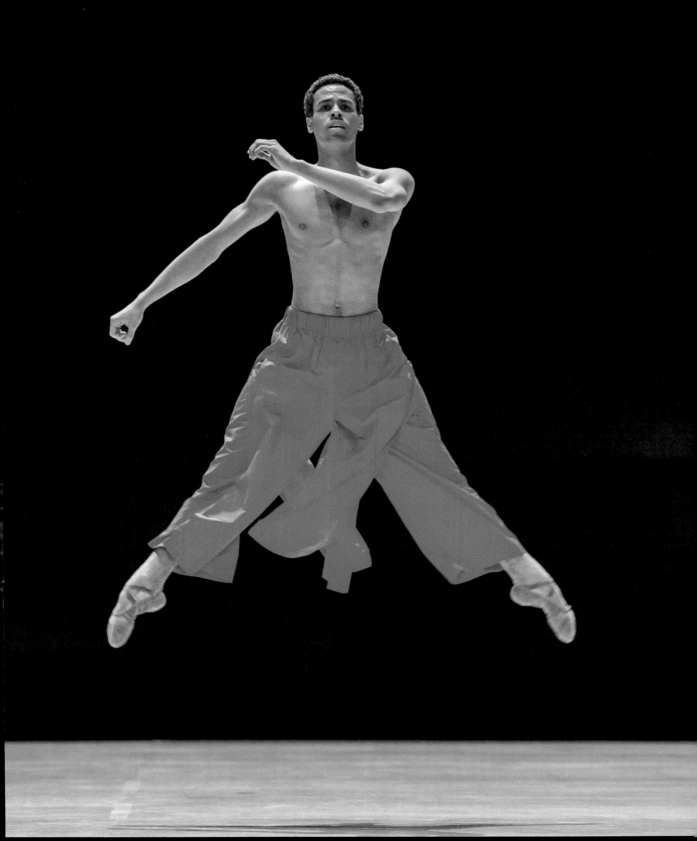

October

4 Monday

5 Tuesday

6 Wednesday ●

Pitr-paksha ends

7 Thursday

Navaratri begins

8 Friday

9 Saturday

10 Sunday

October

11 Monday

Thanksgiving Day (Canada)
Columbus Day (USA)
Indigenous Peoples' Day (USA)
Health and Sports Day (Japan)

12 Tuesday

◐ 13 Wednesday

14 Thursday

Navaratri ends

15 Friday

Dussehra

16 Saturday

17 Sunday

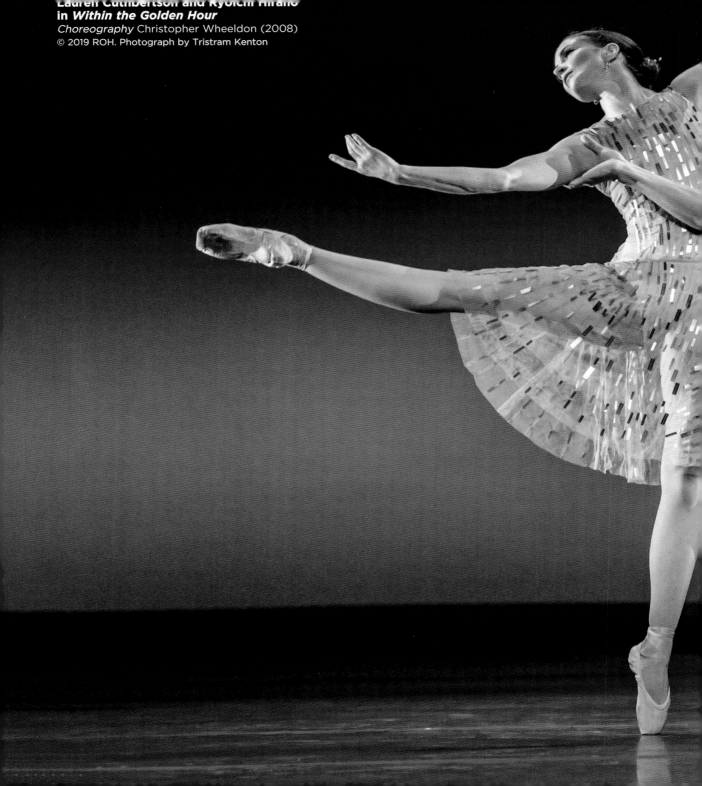

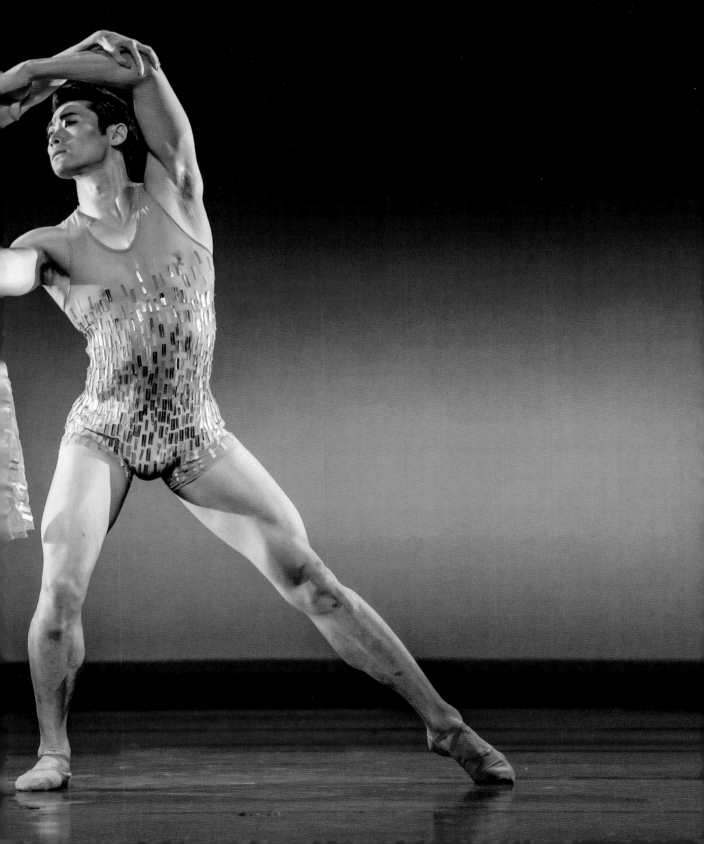

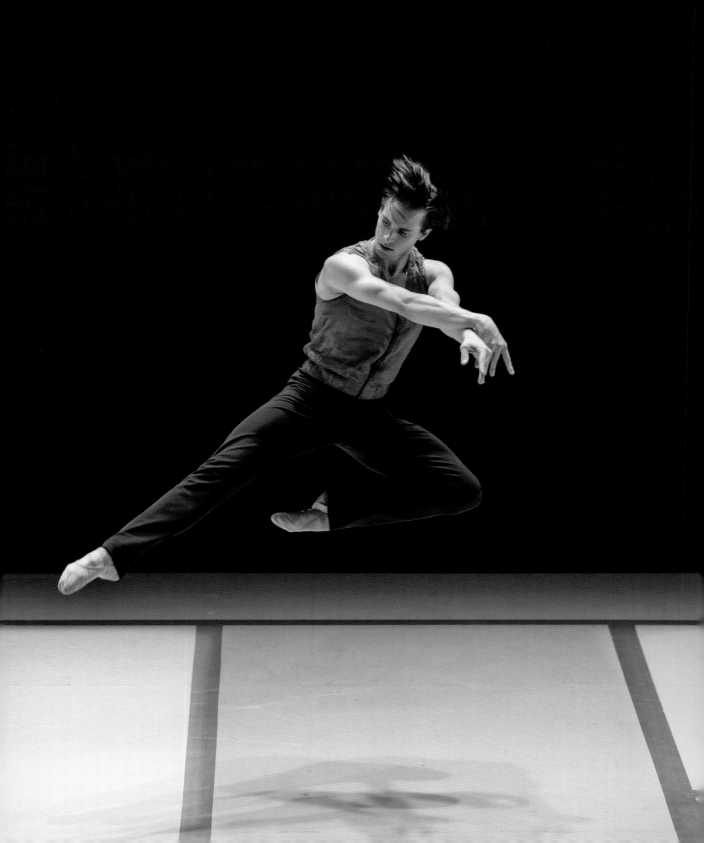

October

18 Monday

19 Tuesday

Birthday of the Islamic Prophet Muhammad

◯ 20 Wednesday

21 Thursday

22 Friday

23 Saturday

24 Sunday

Calvin Richardson in *Everyone Keeps Me*
Choreography Pam Tanowitz (2019)
© 2019 ROH. Photograph by Bill Cooper

October

25 Monday

26 Tuesday

27 Wednesday

28 Thursday

29 Friday

30 Saturday

31 Sunday

Halloween
British Summer Time ends

November

1 Monday

All Saints' Day

2 Tuesday

3 Wednesday

Culture Day (Japan)

● 4 Thursday

Diwali
Bandi Chhor Divas

5 Friday

Vikram New Year

6 Saturday

7 Sunday

November

8 Monday

9 Tuesday

10 Wednesday

11 Thursday ◑

Remembrance Day
(Armistice Day)
Veterans' Day (USA)

12 Friday

13 Saturday

14 Sunday

Remembrance Sunday

Nicol Edmonds and Fumi Kaneko in *Infra*
Choreography Wayne McGregor (2008)
© 2018 ROH. Photograph by Helen Maybanks

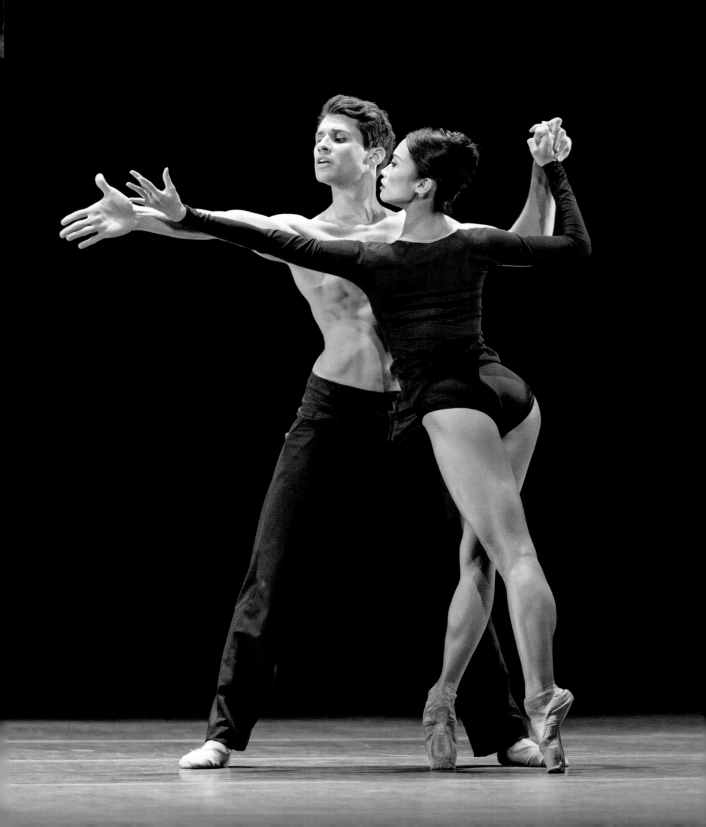

November

15 Monday

16 Tuesday

17 Wednesday

18 Thursday

Birthday of Guru Nanak

19 Friday

○

20 Saturday

21 Sunday

November

22 Monday

23 Tuesday

Labour Thanksgiving Day (Japan)

24 Wednesday

Martyrdom of Guru Tegh Bahadur

25 Thursday

Thanksgiving Day (USA)

26 Friday

27 Saturday

28 Sunday

Advent Sunday

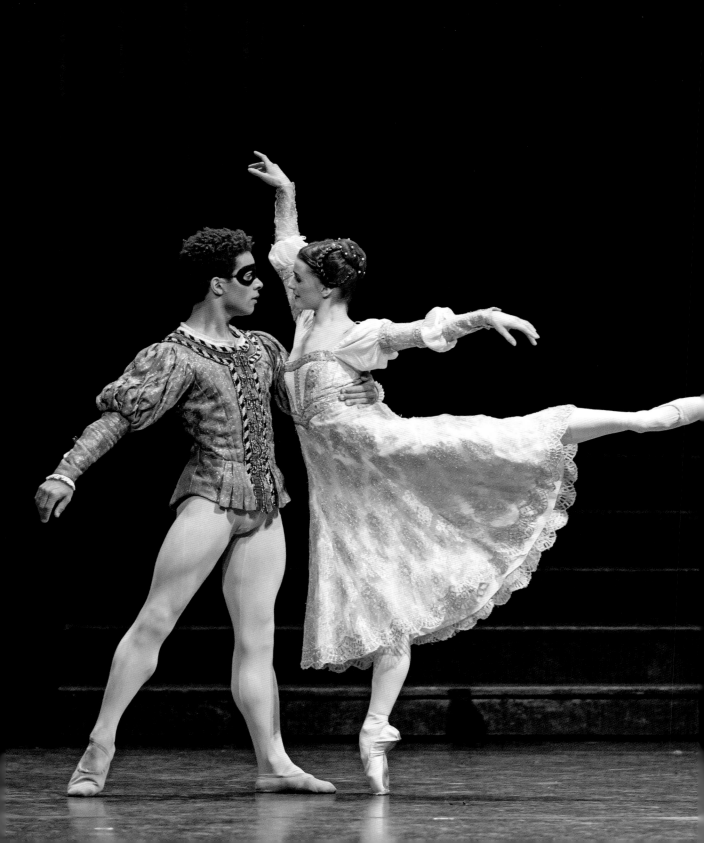

November/December

29 Monday

Hanukkah begins

30 Tuesday

St Andrew's Day (Scot)

1 Wednesday

2 Thursday

3 Friday

● 4 Saturday

5 Sunday

**Marcelino Sambé as Romeo and Anna Rose
O'Sullivan as Juliet in *Romeo and Juliet***
Choreography Kenneth MacMillan (1965)
© 2019 ROH. Photograph by Helen Maybanks

December

6 Monday

Hanukkah ends

7 Tuesday

8 Wednesday

Bodhi Day

9 Thursday

10 Friday

11 Saturday ◑

12 Sunday

Claire Calvert as Hermione in *The Winter's Tale*
Choreography Christopher Wheeldon (2014)
© 2016 ROH. Photograph by Bill Cooper

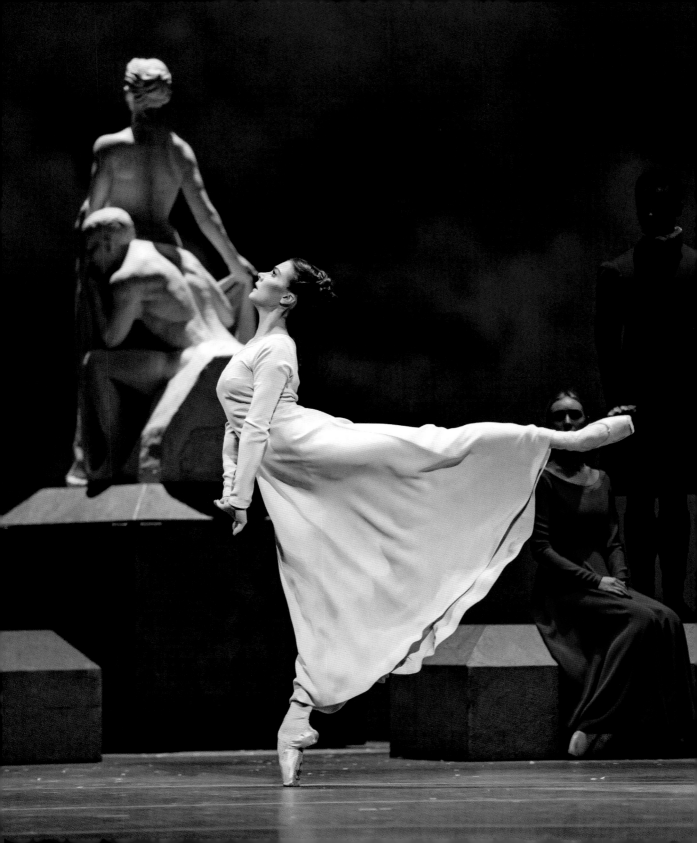

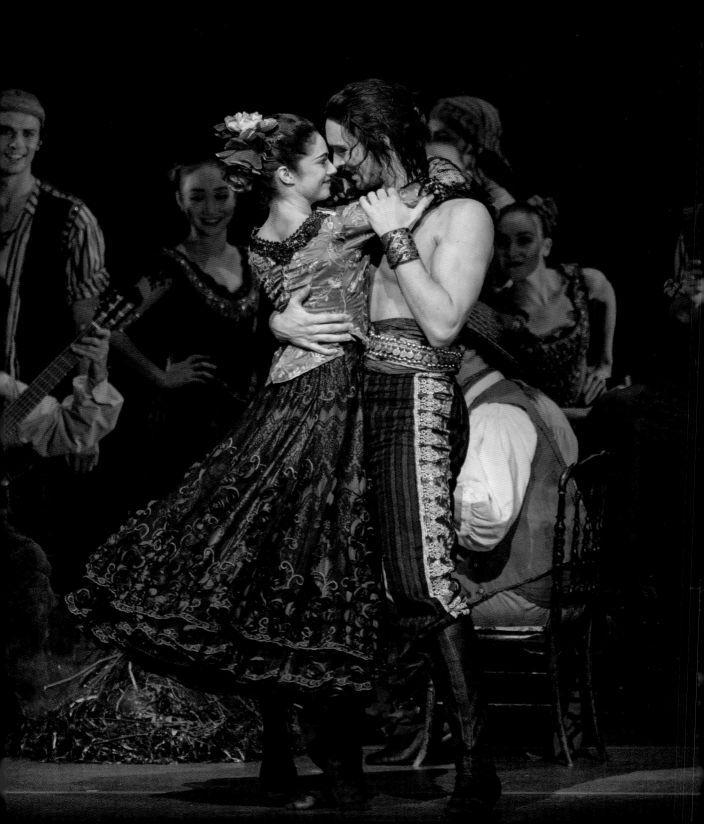

December

13 Monday

14 Tuesday

15 Wednesday

16 Thursday

Day of Reconciliation (SA)

17 Friday

18 Saturday

19 Sunday

Romany Pajdak and Lukas Bjørneboe Brændsrød as the Gypsy Couple in *Don Quixote*
Choreography Carlos Acosta (2013) after Marius Petipa
© 2019 ROH. Photograph by Andrej Uspenski

December

20 Monday

21 Tuesday

Winter Solstice

22 Wednesday

23 Thursday

24 Friday

Christmas Eve

25 Saturday

Christmas Day

26 Sunday

Boxing Day
St Stephen's Day (Éire)
Day of Goodwill (SA)

Sarah Lamb and artists of The Royal Ballet in *The Concert*
Choreography Jerome Robbins (1956)
© 2018 ROH. Photograph by Alice Pennefather

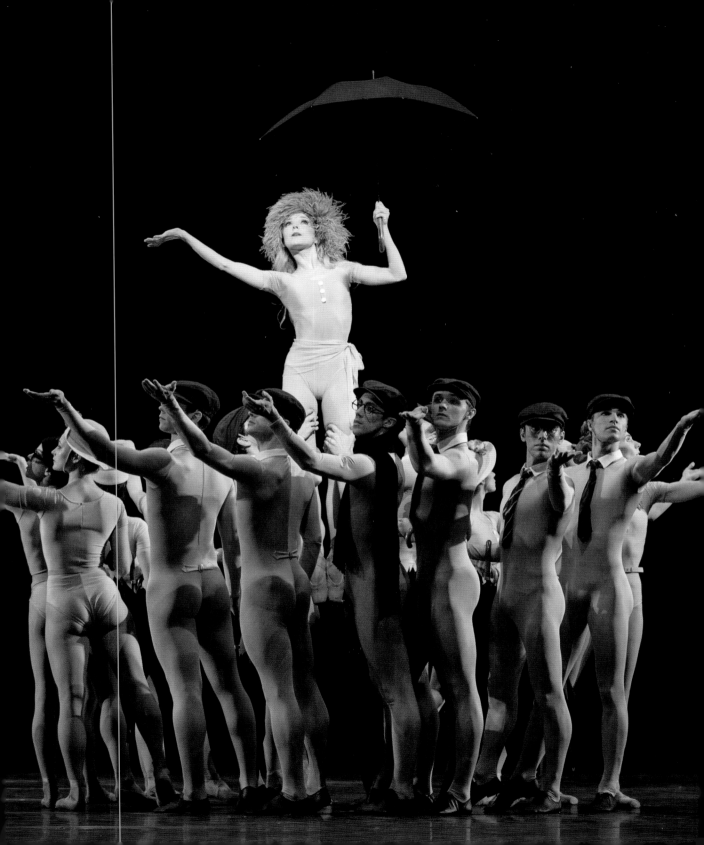

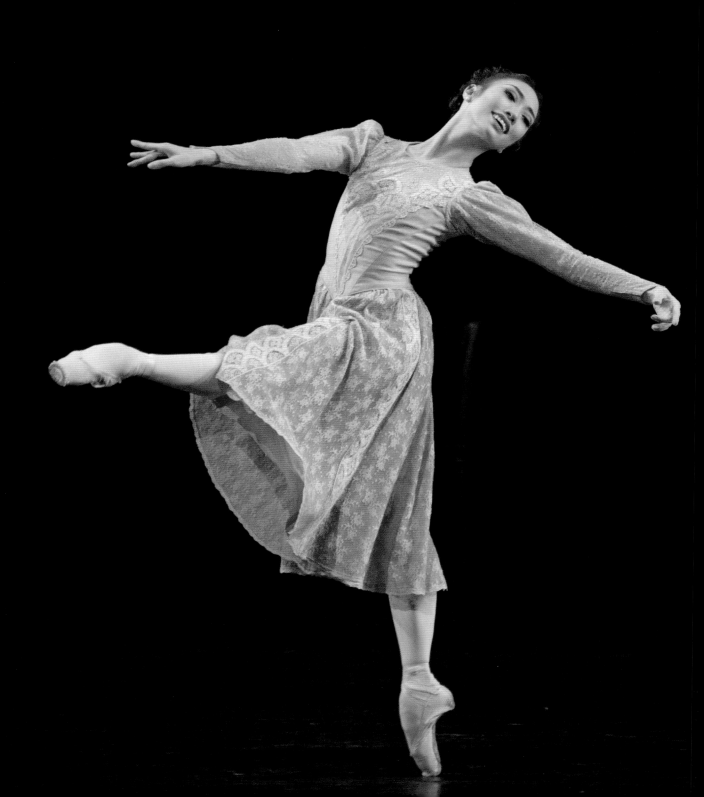

December/January 2022

◐ **27 Monday**

Christmas Day (observed)
Day of Goodwill (SA) (observed)

28 Tuesday

Boxing Day (observed)
St Stephen's Day (Éire) (observed)

29 Wednesday

30 Thursday

31 Friday

New Year's Eve

1 Saturday

New Year's Day
● **2 Sunday**

Akane Takada as Irina in *Winter Dreams*
Choreography Kenneth MacMillan (1991)
© 2018 ROH. Photograph by Alice Pennefather

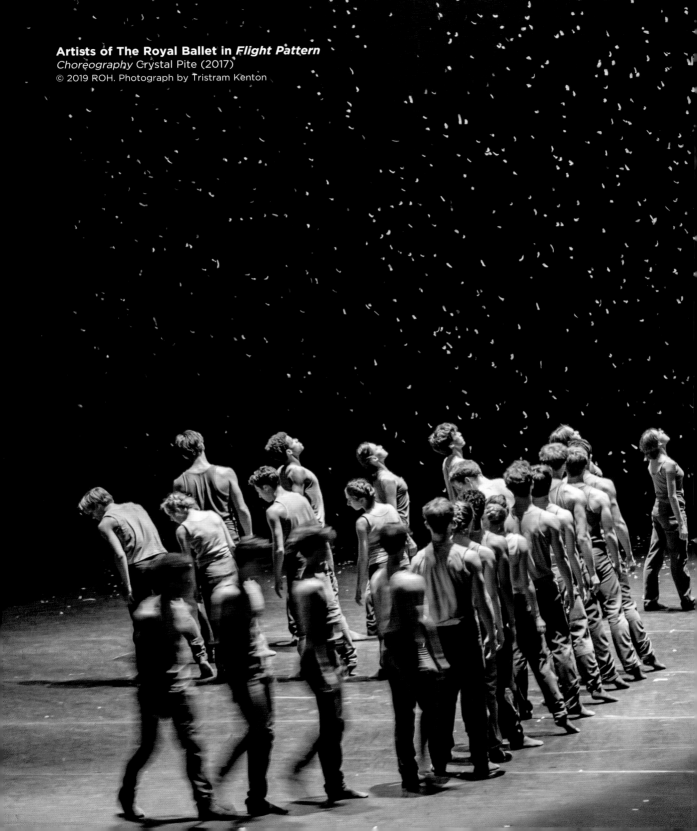

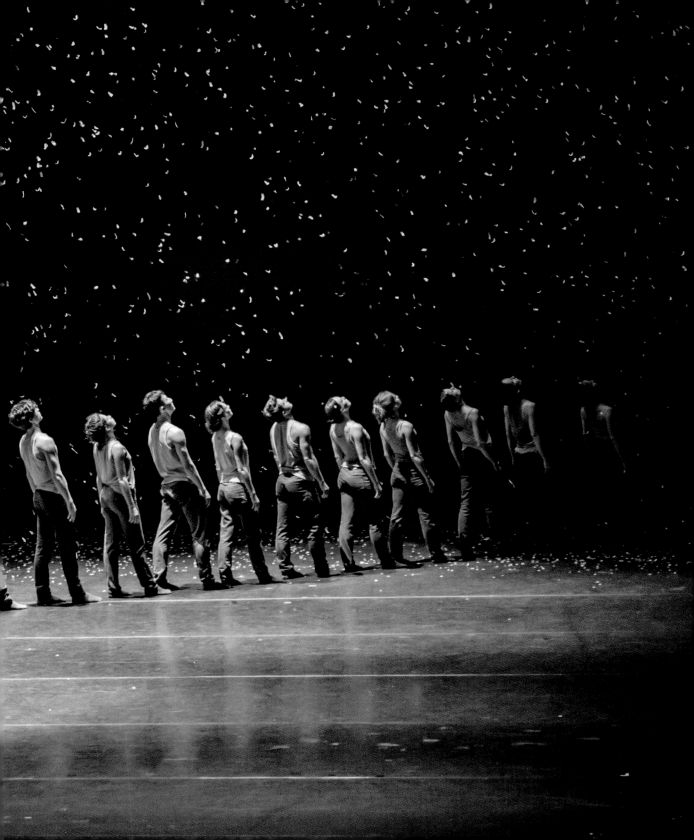

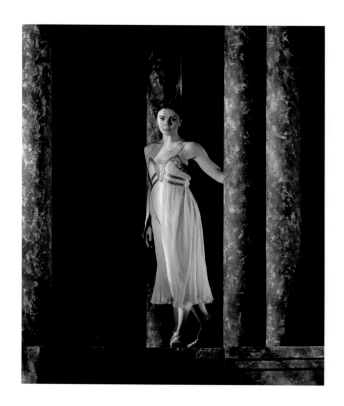

Natalia Osipova as Juliet in *Romeo and Juliet*
Choreography Kenneth MacMillan (1965)
© 2019 ROH. Photograph by Helen Maybanks